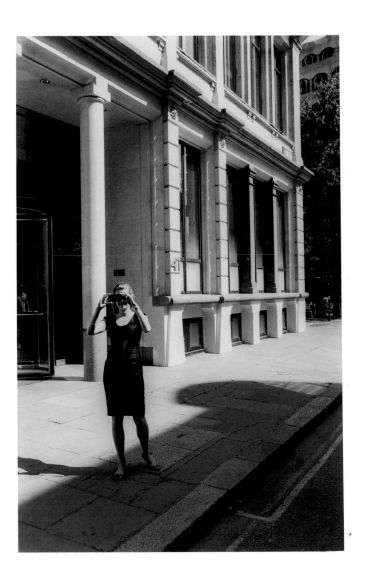

LOST IN THE CITY

by Nicholas Sack

HOXTON MINI PRESS

To order books, collector's editions and signed prints go to:

www.hoxtonminipress.com

East London Photo Stories

Book Eight

REGIMENT OF SHADOWS

Iain Sinclair

The definition of a great city is that it is somewhere in which it is still possible, in the age of the app, to get profitably lost. Materially, ethically, spiritually. An urban otherness where the official map is never enough. The most provocative and inspiring puzzles, as Nicholas Sack reveals, are found among the towering banalities of post-architectural infill around Canary Wharf and the time-fouled weight of established cathedrals of commerce in the purlieus of Bishopsgate, Leadenhall Market and Cheapside. The essence of London, its spirit and spite, recovered from plague and fire and invasion, is located in the original City: that walled labyrinth of signs and symbols, close alleys, private squares, carbon-blackened churches and permitted strips of sky glimpsed in dark chasms between unexplained walls of light-swallowing monoliths. Here is a city of credit and discredit: gentlemanly frauds, parasitical trades and crafts, arcane rituals of entitlement and Masonic affiliations confirmed in the basement of a station hotel.

The machinery of capital is made visible through the stuttering movements of an army of clerks, drones, polishers of screens, facilitators who seem to be always in a hurry, late

for appointments or stalled at a crossing. They are smartly dressed in dark clothes in which they are never quite comfortable. Like petty miscreants waiting outside courts in Liverpool or Leeds. In summer, when jackets come off, the City tribe might be laptop reps plotting the day's targets in a service station breakfast bar. But this is our London, the post-Olympic World City. Beyond surviving fragments of the massive curve of Roman Wall, anchored by the grim bastion of the Tower of London, are come-lately suburbs and old collided villages, property fiefdoms and deserted stucco terraces owned by offshore investors. Those places are not part of this story.

Sack has such a nicely weighted ambiguity in his title, *Lost in the City*. He makes reference to his own obsession, the way the seductive gravity of place draws him inwards, time and again, and the way the figures he photographs, stalled or striding out, are estranged, alienated, trapped between the cruel geometry of painted lines and the narcoleptic classicism of Giorgio de Chirico and Paul Delvaux. These haunting, but hard-edged retrievals define a zone that many have noticed but few have stared at with such determination to identify the salient detail, the smallest gesture of arm or hand. Sack's impulse is always centripetal. Like an agent from another galaxy, he drifts with the crowd, anonymous but alert, 35mm SLR camera primed and pre-set. When he has recognised the backdrop with the elements he requires (grids, regular window patterns, trompe-l'oeil effects), he waits. Freezing the

moment and bearing it home across the river, a potent fiction of reality begins to emerge from the silver prints he makes in his alchemist's darkroom. Sack is a detective compiling evidence. The musician he once was responds to visual rhythms, motifs and repeated architectural riffs.

The precision of the image-making process is such that even slight shifts of geography, downriver to Docklands, across London Bridge to Tooley Street, or west towards Holborn and Bloomsbury, are felt in a change of clothes, heavier luggage, lighter buildings. Going beyond the now invisible barrier of the City walls seems to offer a release of tension, a drop in the level of surveillance, and less paranoia about the unsanctioned use of private cameras. Sack avoids those tedious interrogations by low-level operatives in hard hats by passing himself off as a tourist, a man of the crowd.

The tension becomes erotic. All that money and power, whispering through the electronic devices with which City walkers are self-tagged, has its consequences. Look how they perch, the solitaries in their late-morning slumps on angled benches taking a quick dole of sunlight. It's beautiful how the photographer produces a narrative through the acuity of his gaze: this one *here*, that one *there*, and away in the extreme distance, if you get out a magnifying glass, another shadowy couple. Two solitaries might be in alignment with a corresponding artwork. There are no accidents in this surreal theatre of place, just recorded acts of recognition.

One strand privileged by the Sack gaze is a form of cinema

reminiscent of Alfred Hitchcock; the cool blonde woman – think of *Marnie* – hurrying towards a covert assignment, long-striding, immaculately tailored, witnessed by a twist of CCTV cameras. And the hidden photographer. Who is always hidden in full sight. He traps the split second when the model reveals her accidental reality by having to strike a ballet pose to adjust a stocking or manage a disobedient shoe. The urban drama of stalker, prey, watcher, photographer, manifested in Hitchcock's *Vertigo* and *Rear Window*, is adapted to the historic yards and passages that surround the Bank of England. In one supremely unsettling print, a young woman lifts her own camera to confront the camera that is confronting her. In truth, as Sack told me, she was recording a huge police horse that loomed up behind him as he waited to make his shot. The thing that is not seen remains part of the story. That group of mesmerised and intent men bunched on a pavement are not stepping away from a bomb threat or participating in a fire drill. They are trying to watch the sport on the screen of a too crowded, too hot pub.

Sack speaks of cultivating the ability to *witness*, in a fraction of a second, the conjunction of stone, steel, glass, paint and living human presence. Within so many of the prints, when you give them the attention they deserve, is the tiny flaw that confirms the capture as something more than technical facility, the cadence of a well rehearsed system of values. Keep your eyes peeled for that scrap of litter, a white spot on the immaculate grey of the pavement. Notice the

position of the walker's swinging hand. Register that modest abrasion in the concrete, the fossil traces in Portland stone. The marchers in their uniform black, their gleaming white shirts, their high heels, discriminations of branded bag and briefcase, progress through the columned avenues of a city of future ruins; a territory with no special interest in its temporary inhabitants, most of whom will vanish as soon as darkness falls. Sack describes his frozen moments as a cartography of 'other-worldliness'.

The discipline of wandering and waiting, and risking the exposure of the instant that achieves significance only when the print is made and contemplated, was learned, as Sack acknowledges, from the photographer Henry Wessel, who speaks of his arrival in California as a stepping into the light where images have to be made. The City of London has its special forms of darkness and its guillotine shadows. Nicholas Sack has joined the company of those who have made a record of the skein of contemporary life to play out against the forms of a troubled past, the empty narcissism of a virtual future. I can't offer higher praise than to say that this portfolio of City walkers sent me back to Robert Frank's 1951 City of London exposures, where the polished hats and funereal coats of entitled bankers take their turn to parade the eternal treadmill of the same streets.

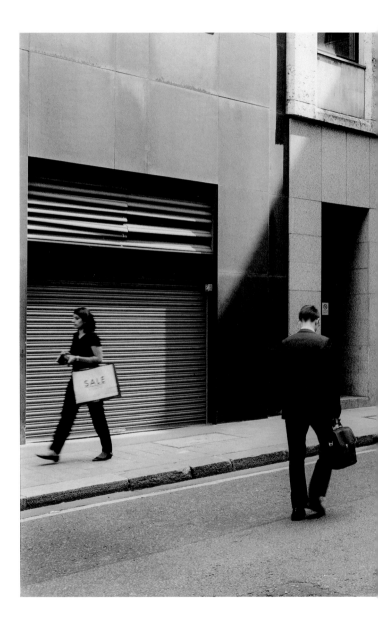

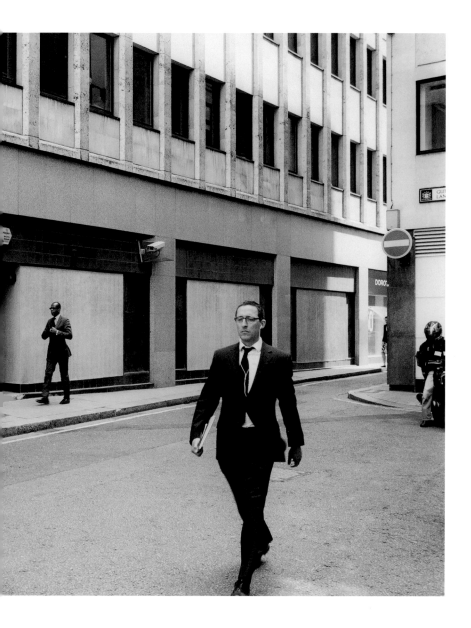

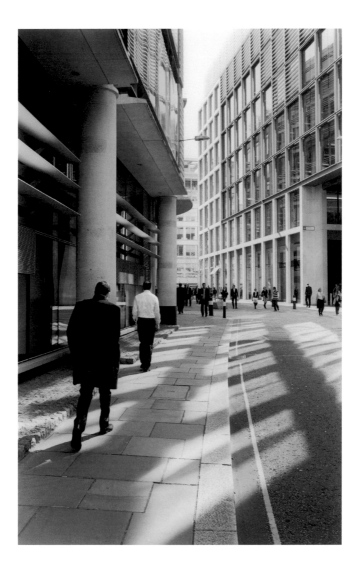

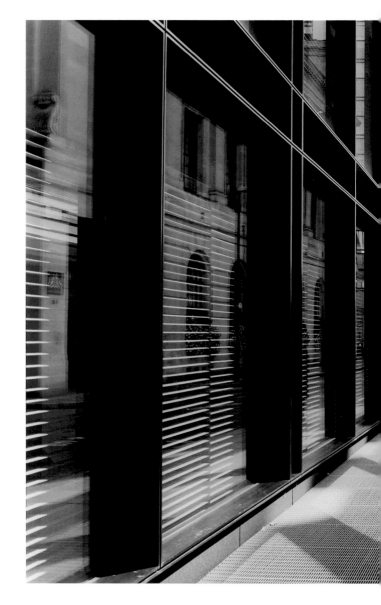

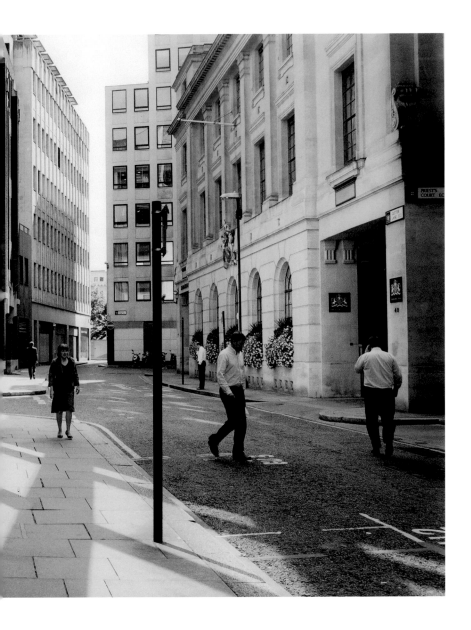

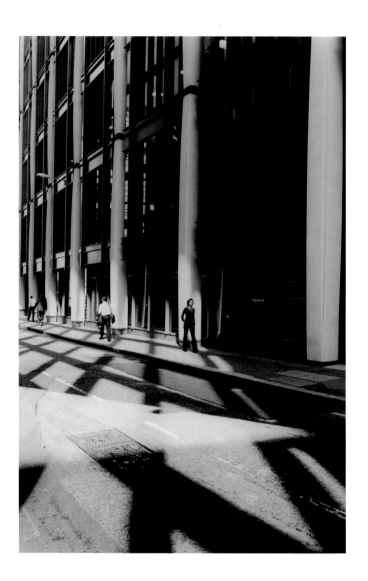

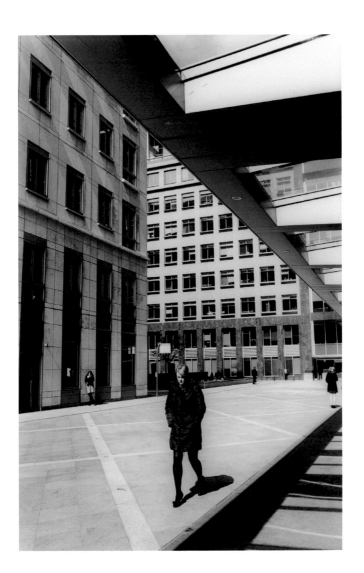

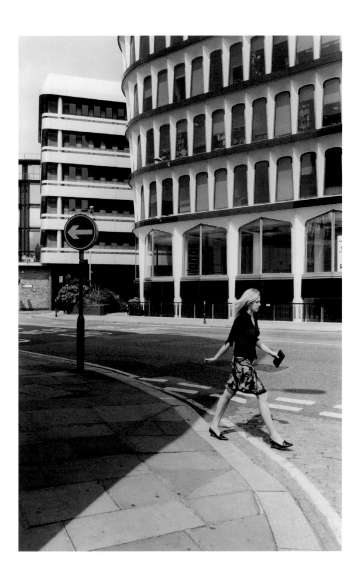

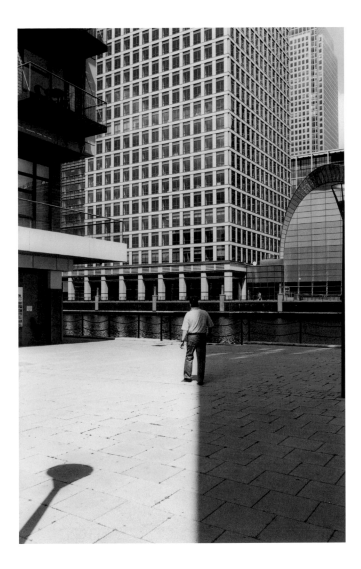

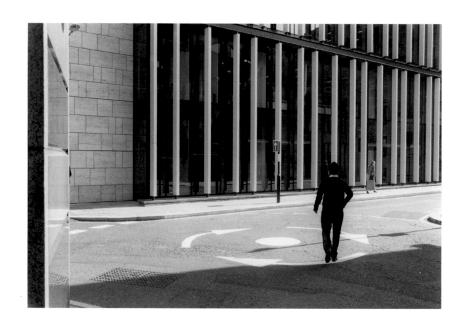

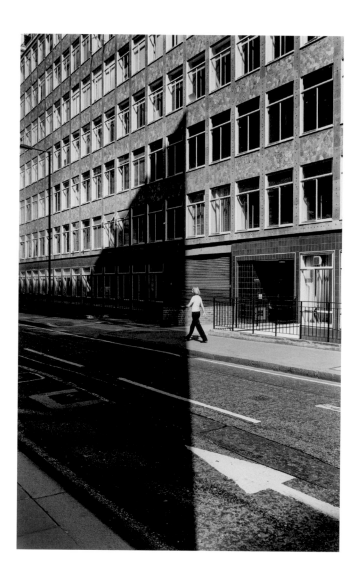

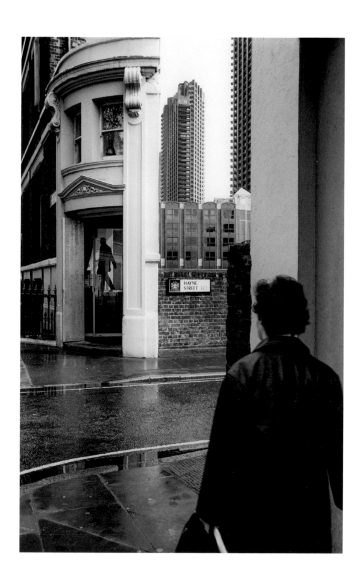

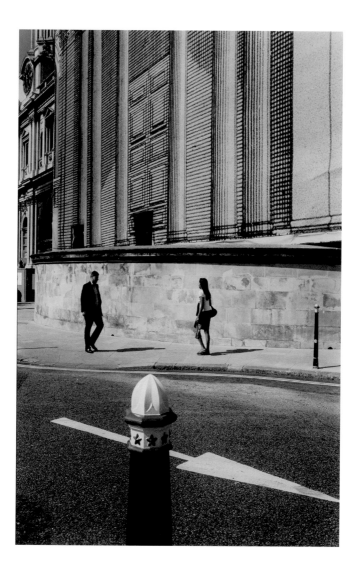

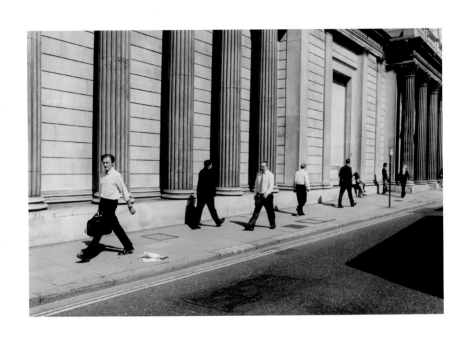

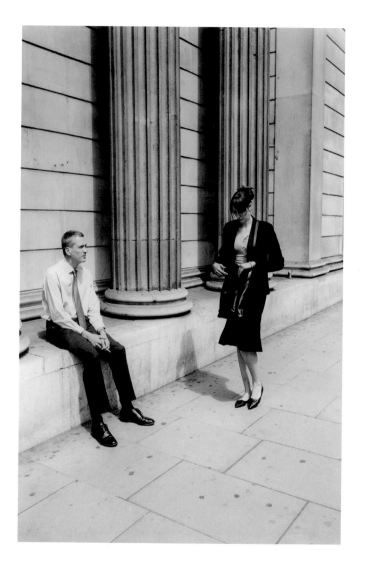

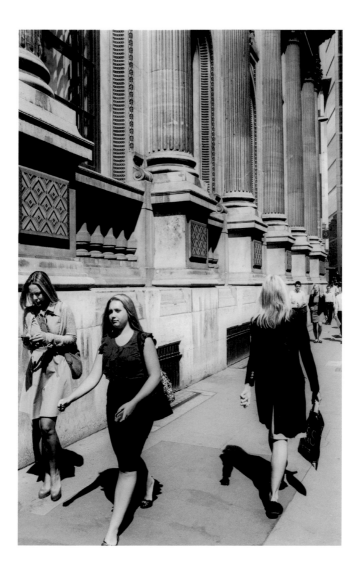

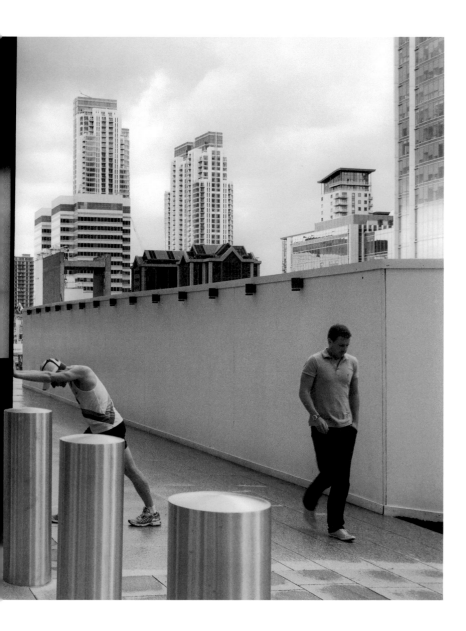

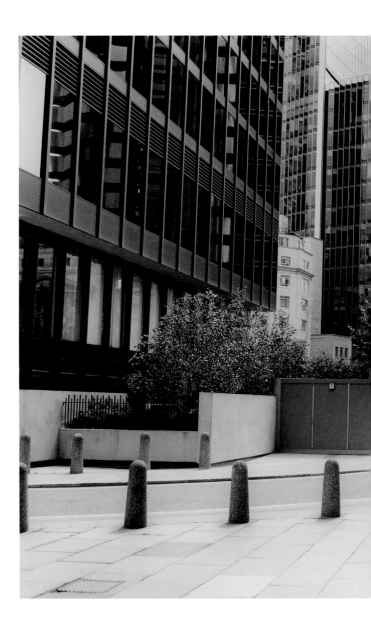

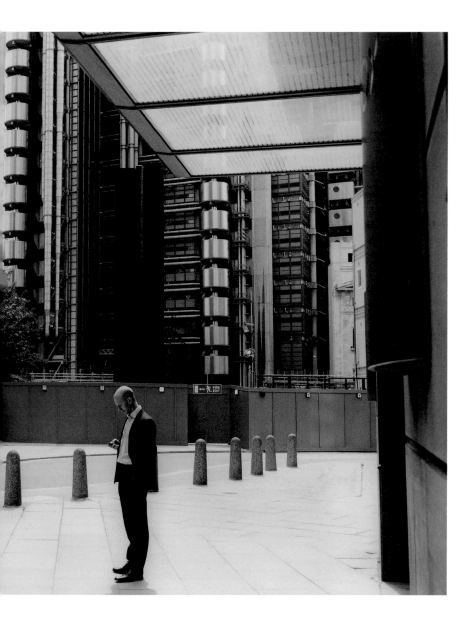

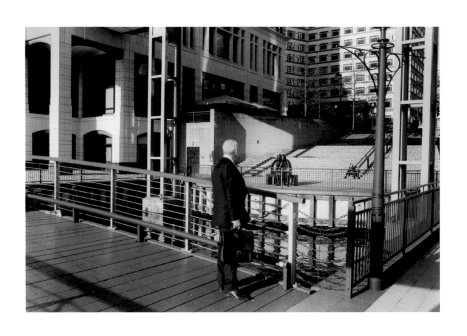

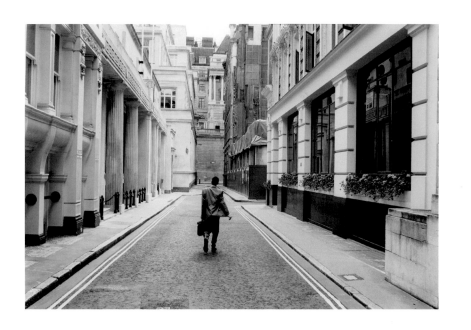

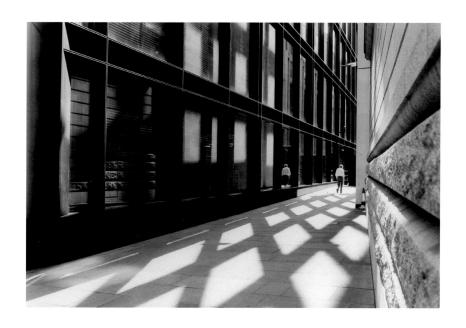

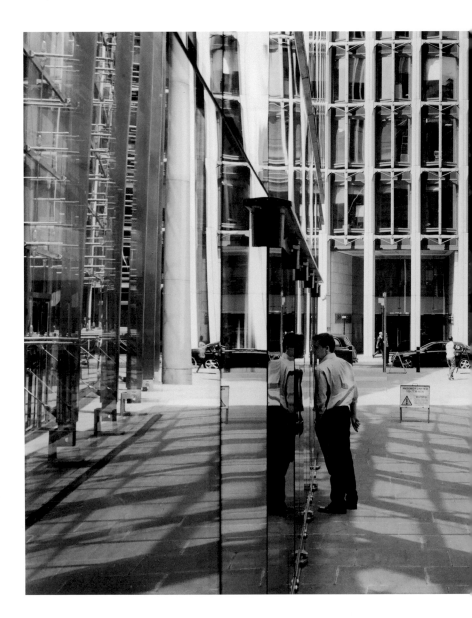

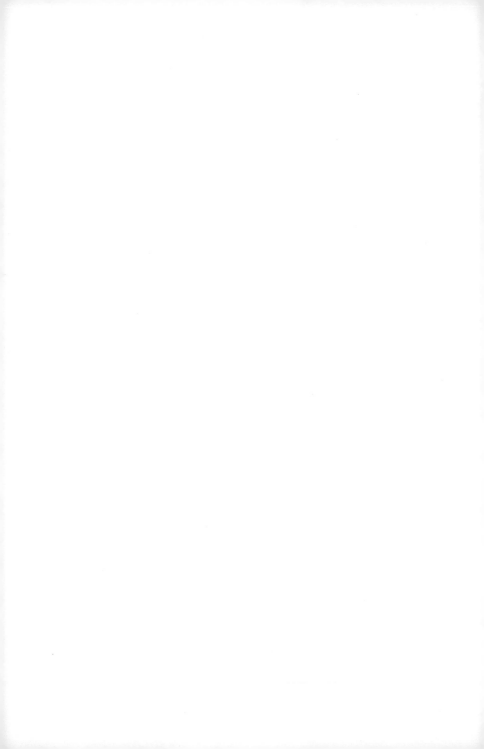

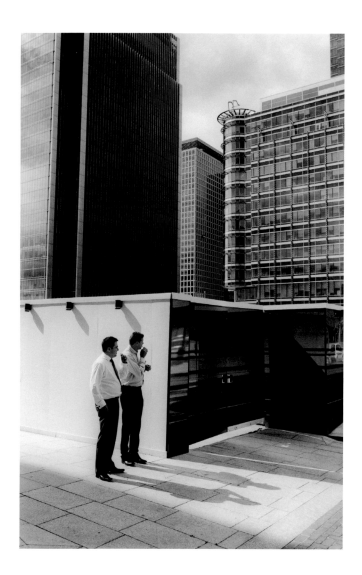

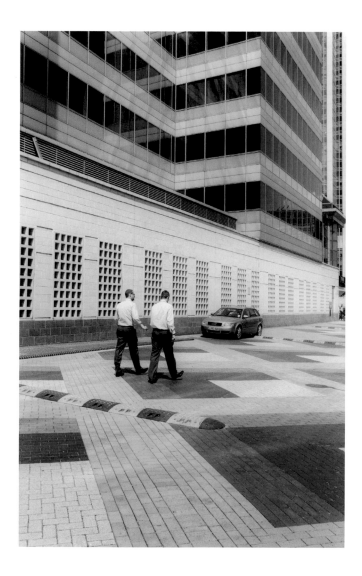

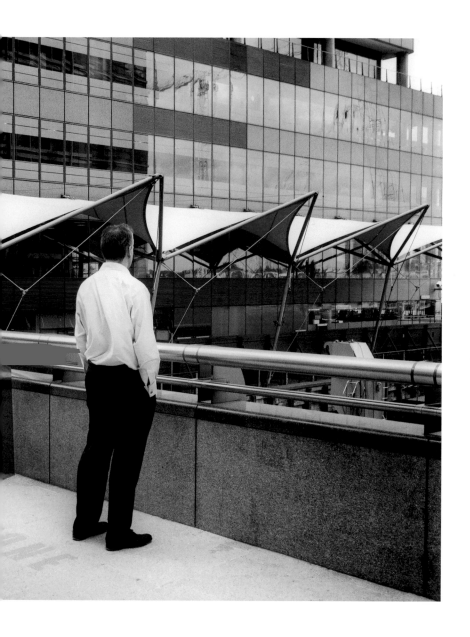

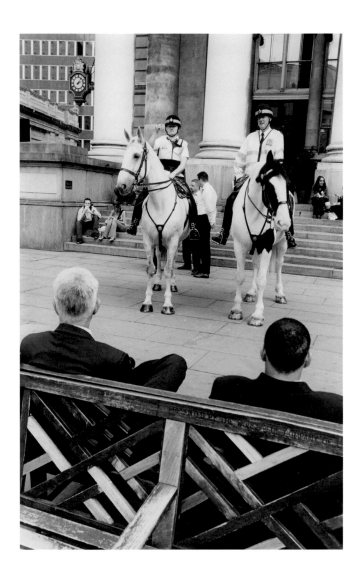

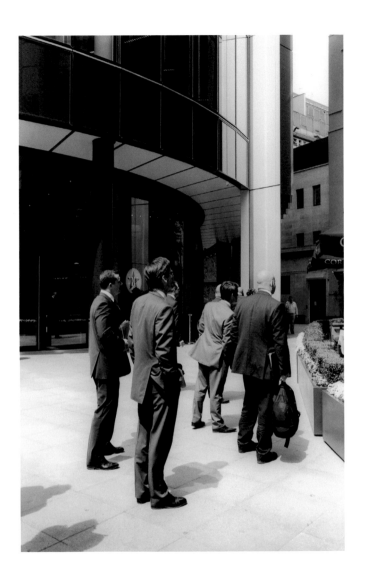

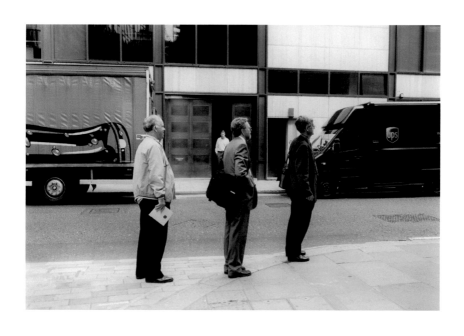

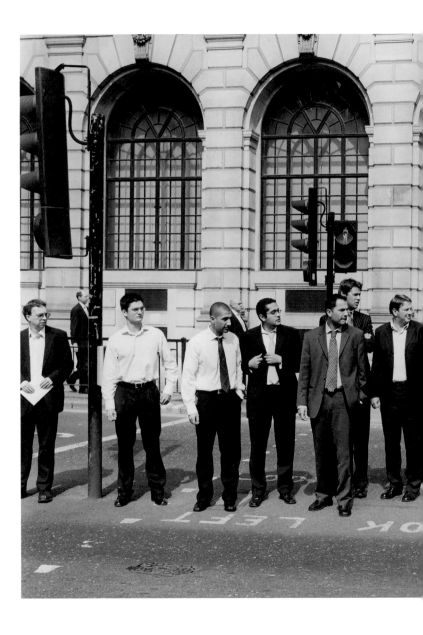

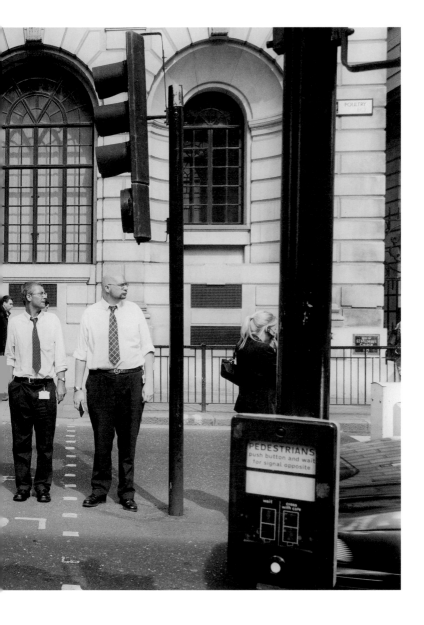

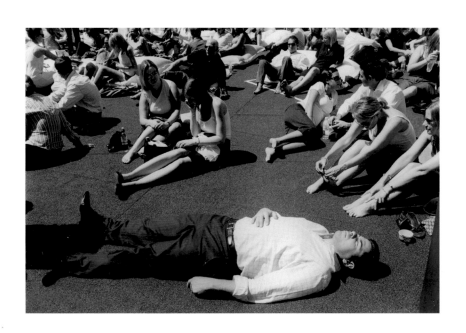

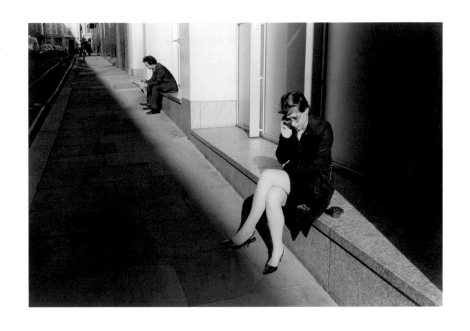

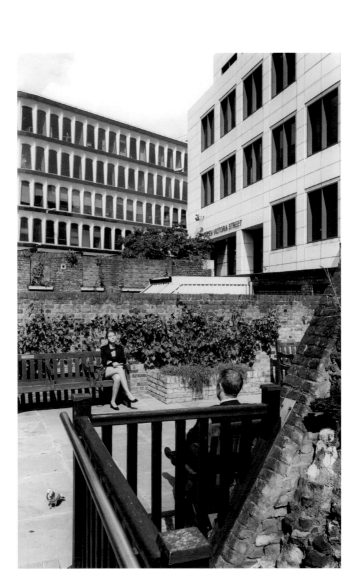

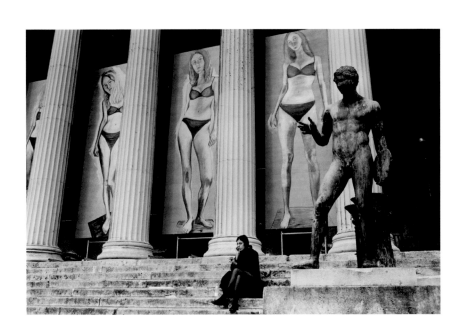

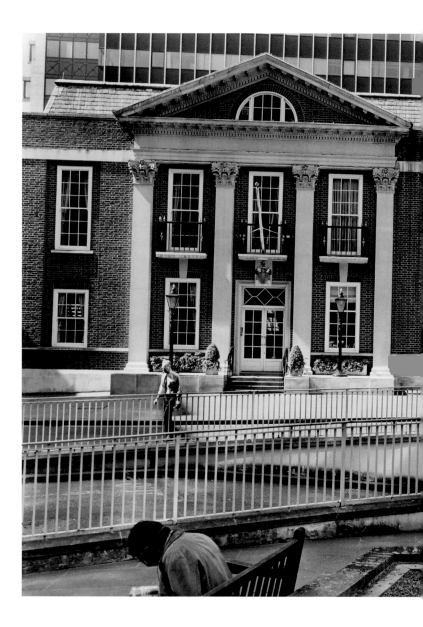

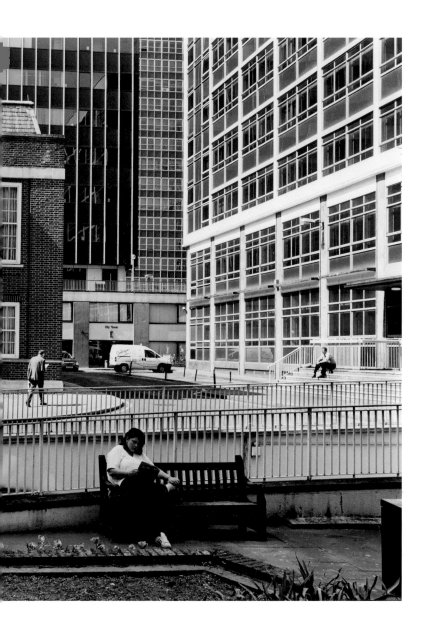

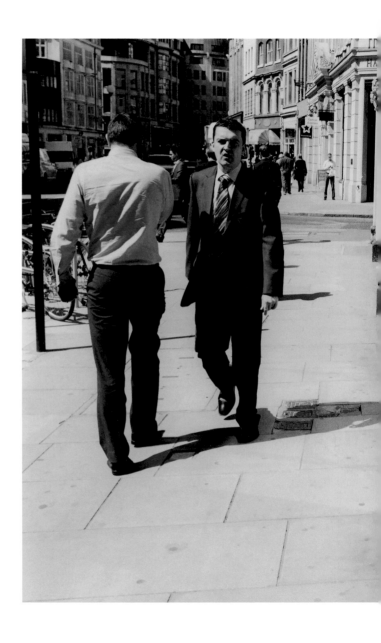

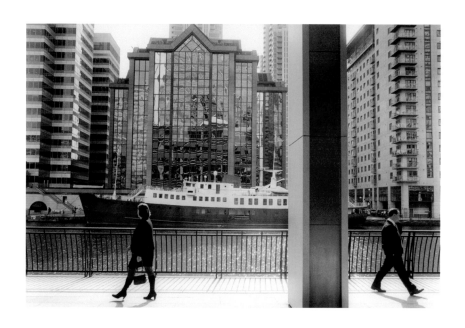

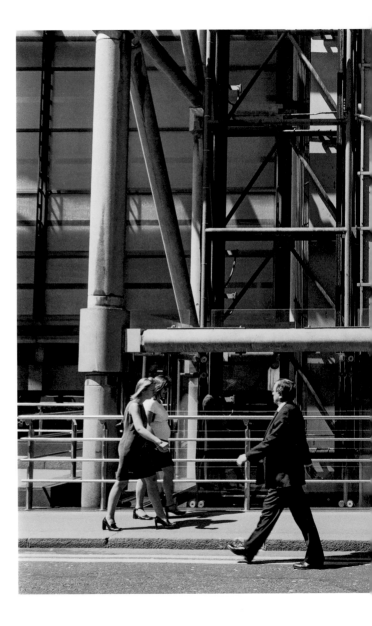

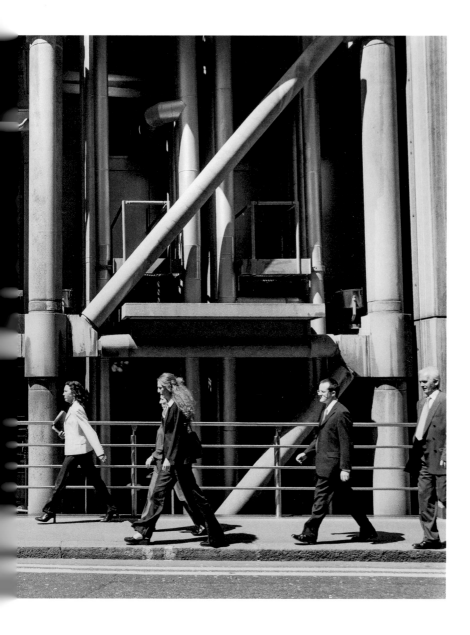

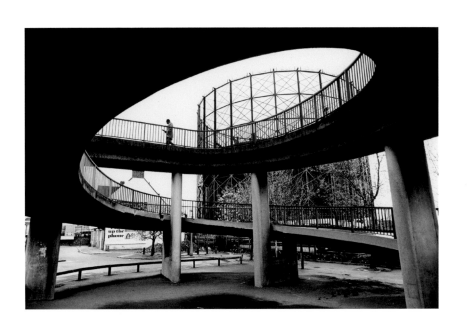

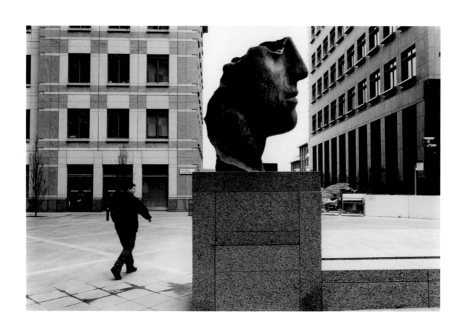

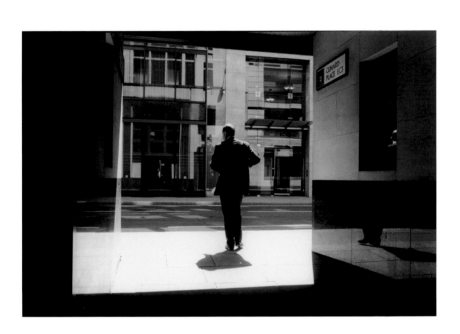

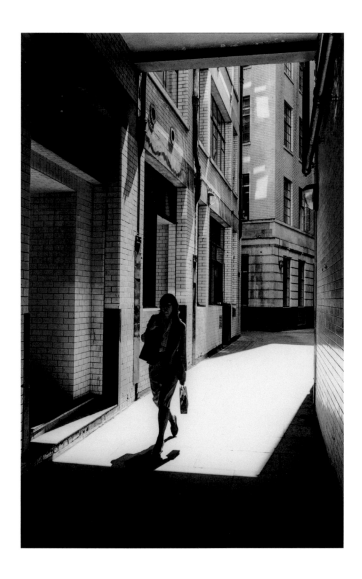

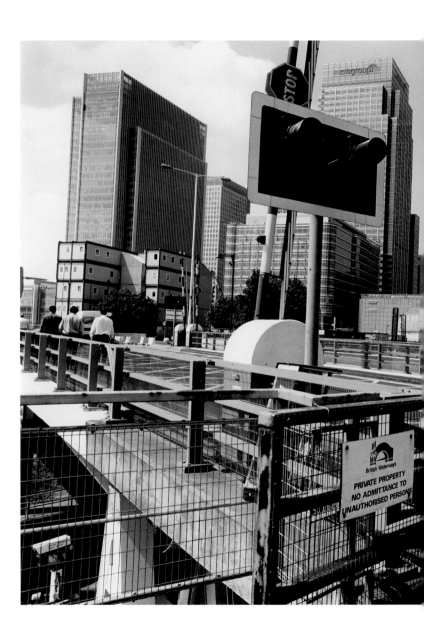

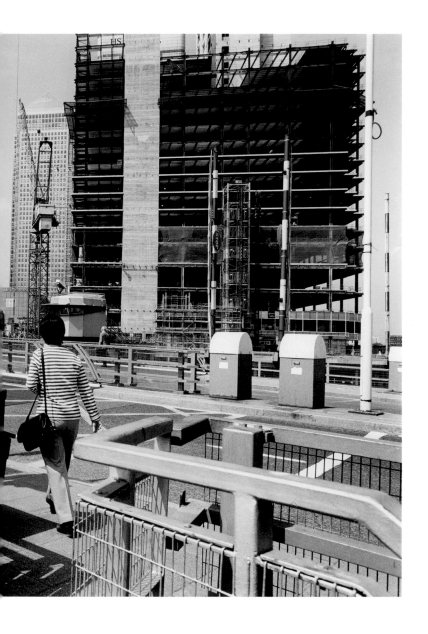

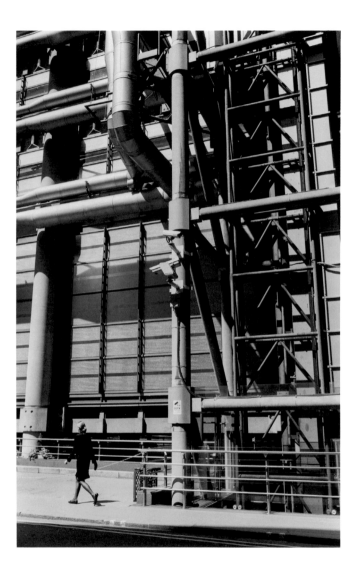

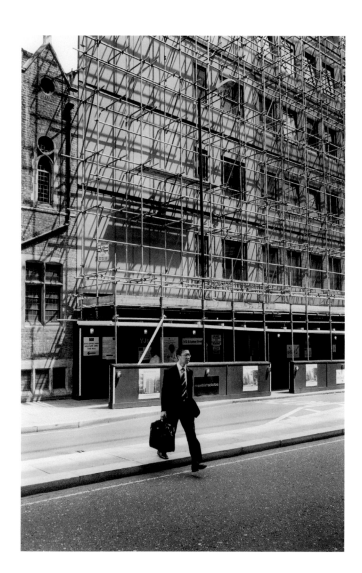

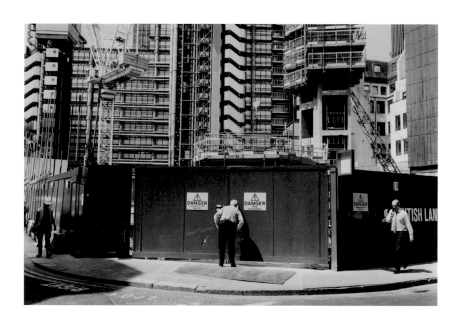

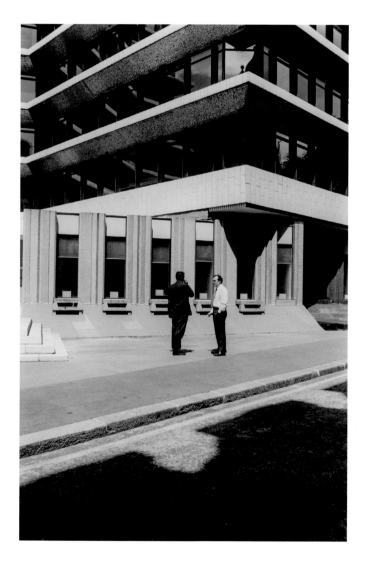

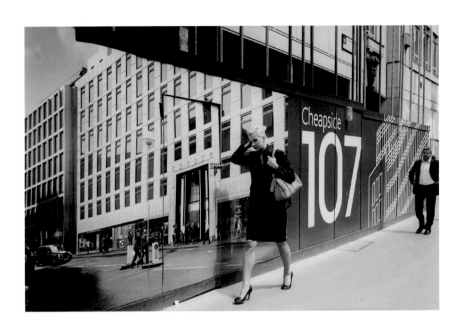

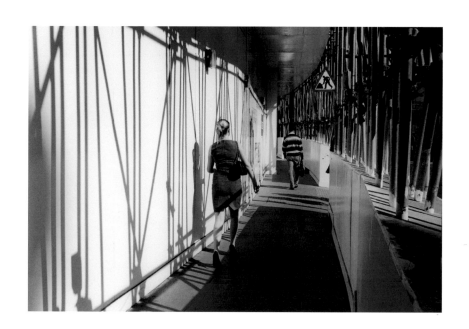

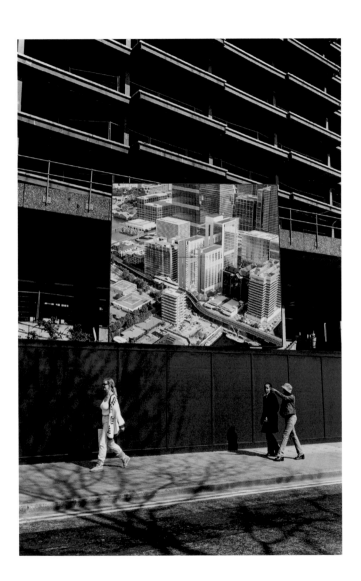

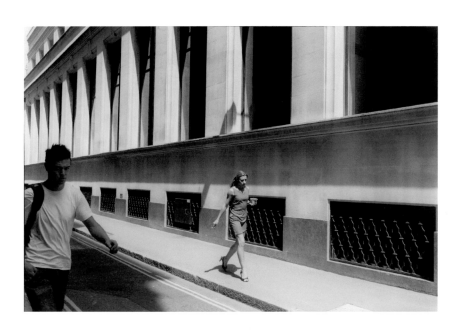

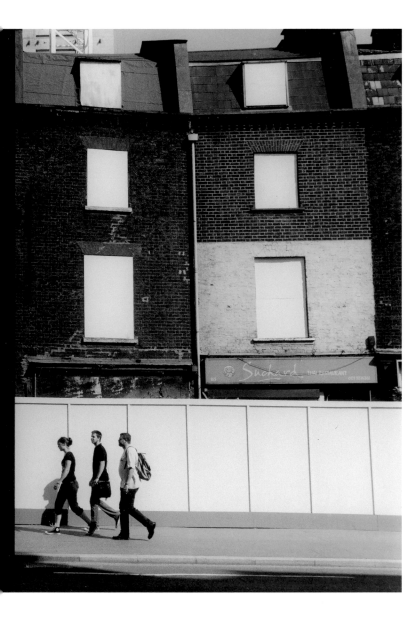

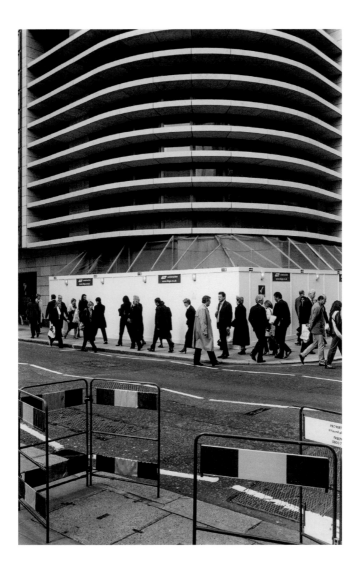

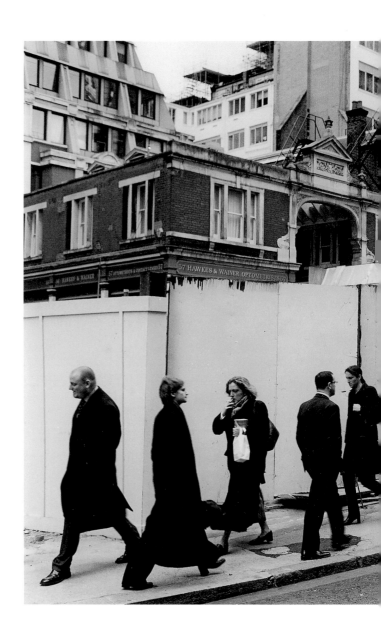

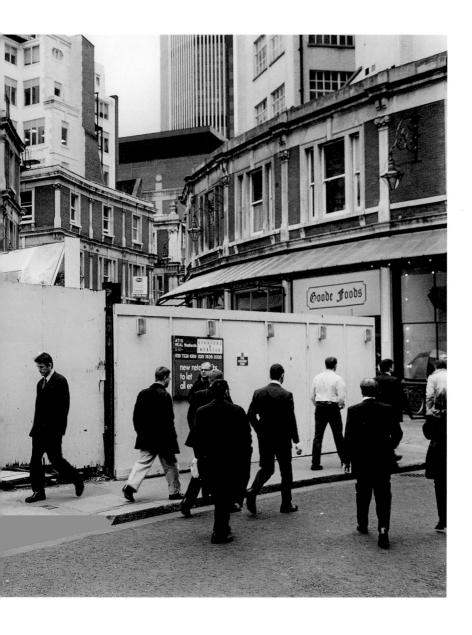

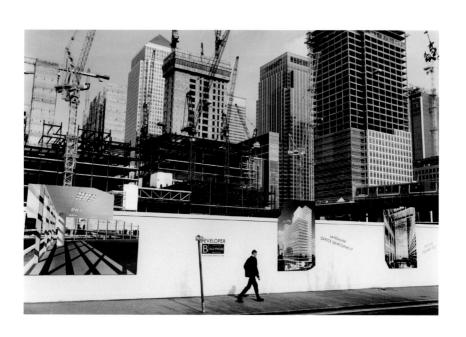